CONTENTS

LEGACY OF DESTRUCTION: DEATHWING....6

THE END OF ALL THINGS: TWILIGHT'S HAMMER....16

A CHANGING WORLD: KALIMDOR
AND THE EASTERN KINGDOMS....38

LOCK THE DOORS: GILNEAS....60

MESSAGE IN A BOTTLE: KEZAN AND THE LOST ISLES....82

FORGOTTEN DEPTHS: VASHJ'IR....106

MYSTERIES IN THE SANDS: ULDUM....126

REALM OF FURY: THE ELEMENTAL PLANE....138

LEGACY OF DESTRUCTION: DEATHWING

Sentinels,

I wish I were writing with news that would lift your hearts, but the purpose of this missive is much bleaker. I have received word that *Xaxas*, or Deathwing as he is called in some tongues, has returned. It is he who is responsible for the rampant destruction that has hit Azeroth. For those of you who were born after our war with the Burning Legion over ten thousand years ago, know that we once considered this dragon a protector of the world. Yet we were not aware that treachery was brewing in his heart... a truth revealed when he murdered our kin and even his own dragon brethren when we needed him most.

Doubtless even the youngest among you are familiar with the schemes that he orchestrated in the ages that followed, including his disappearance nearly two decades ago. In light of the catastrophe that has just transpired, it seems that during his absence Deathwing has grown more powerful than ever before. I know not what fuels his rage, nor what he plans next. He is a creature we cannot reason with. All that we can do is steel ourselves in preparation for what is to come, and remain ever vigilant.

Elune be with you all.

—General Shandris Feathermoon

THE END OF ALL THINGS: TWILIGHT'S HAMMER

Lord Ebonlocke,

A number of townsfolk are complaining about someone nailing disturbing letters to their doors in the middle of the night, but no one has been able to identify the culprit. I have included one of these letters for your review.

*The master calls, echoing death and destruction across the globe.
The earth bellows, fissures devouring the weak and the strong alike.
The wind howls, snatching up bodies like leaves in the breeze.
The water screams, shearing coastlines with the ease of a scythe through grain.
The fire roars, turning plains and forests to charcoal and ash.
The Twilight's Hammer descends, and all of Azeroth will hear its knell.*

*Add your voice to our glorious chorus,
For it is the song that will end the world.*

I fear that this "Twilight's Hammer" may be trying to play off the fear caused by recent reports from Stormwind, Lakeshire and Westfall. I have already placed the Night Watch on high alert and will update you with any further news as I hear it.

Respectfully,
Role Dreuger

ALTAR OF ASCENSION

ELEMENTAL SPINE-CAGE

TWILIGHT FORTRESS

* Twilight's Hammer - Magical Devices *

TWILIGHT HIGHLANDS

ENTRANCE DETAIL

TWILIGHT'S HAMMER BUILDINGS

Twilight's Hammer- Watchtower.

TWILIGHT'S HAMMER- PRIESTESS

TWILIGHT FORTRESS

TWILIGHT FORTRESS

TWILIGHT'S HAMMER-CART

TWILIGHT'S HAMMER- CULTIST

— TWILIGHT'S HAMMER OGRE CAMP

TWILIGHT FORTRESS

A CHANGING WORLD: KALIMDOR AND THE EASTERN KINGDOMS

I was in the Southern Barrens when the world broke.

Azeroth wrenched. Jagged maws of stone and dirt opened all around me. I turned in horror to see that my elder brother, Kor'ak, was falling into one of the gaping fissures. With all my might I struggled to pull him free, but in that moment, when he needed me most... I failed him. The screaming rift snapped shut, rending Kor'ak's flesh and bone with sickening ease. Terrified, I fled south to the Great Lift, only to watch as the sea raged through the red canyons of Thousand Needles, consuming all in its path. I then went north until I came upon a fiery chasm that sliced the Barrens in two as if some monstrous demon had cleaved Azeroth's belly with his tainted axe. Despite the chaos, I could not shake Kor'ak's death from my mind.... A brother... friend... proud orcish warrior... crushed like an insect under the foot of a traveler.

Many suns have passed since that day, but I fear that the whole of Kalimdor, and even the distant Eastern Kingdoms, will never be the same again. More and more I hear tales of how these lands have suffered from the upheaval's wrath: fire spewing from the heart of Ashenvale, flooding in the formerly parched lands of Tanaris and Durotar, and coastal settlements in Darkshore and the Wetlands claimed by hungry seas. Azeroth is changing, but I must endure to see that Kor'ak receives an honorable burial. If it takes a lifetime to find my brother's broken body entombed beneath the scarred earth... then so be it.

—Tharkan Bloodspike of the Crossroads

GOBLIN PORT

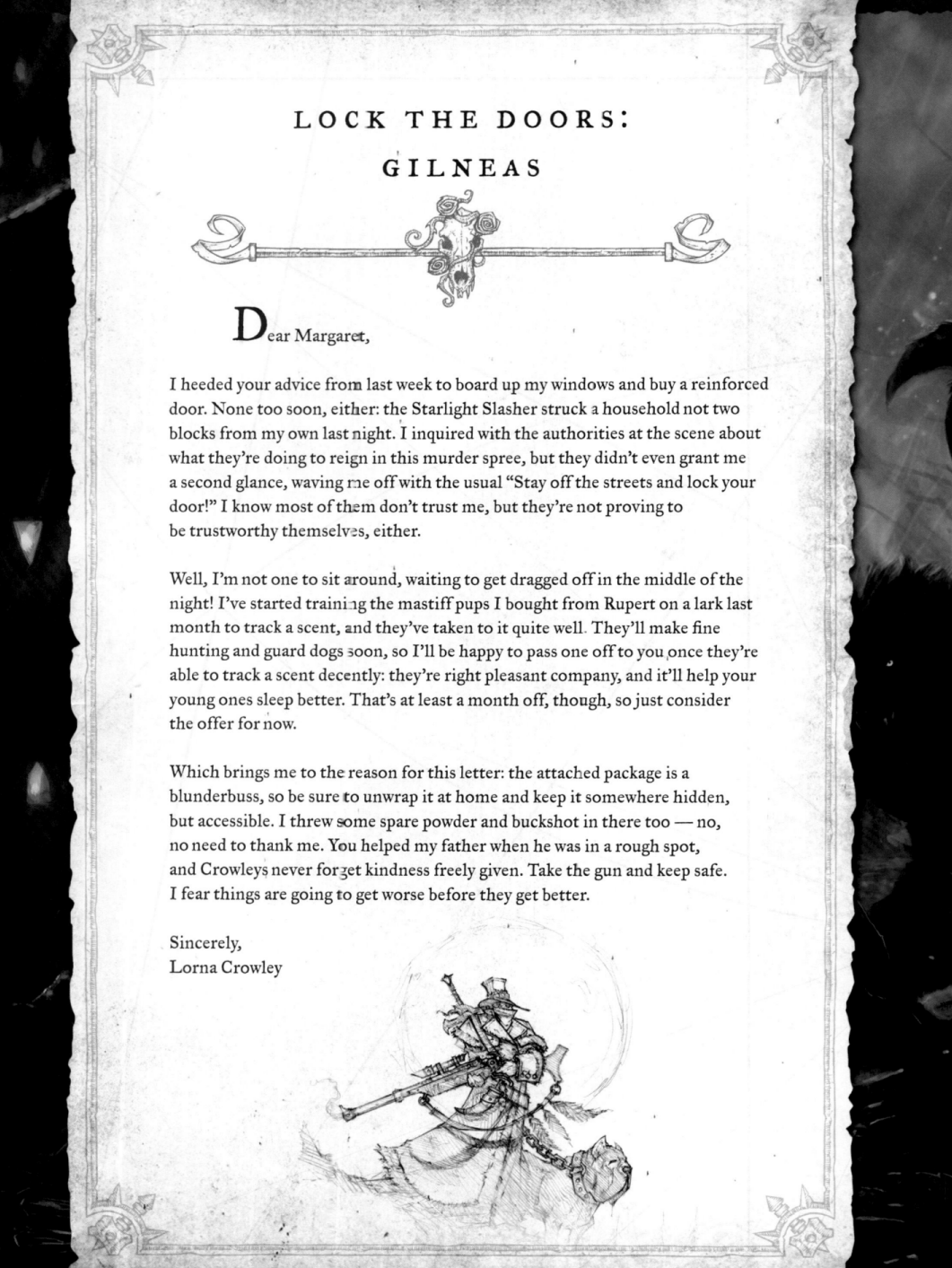

LOCK THE DOORS: GILNEAS

Dear Margaret,

I heeded your advice from last week to board up my windows and buy a reinforced door. None too soon, either: the Starlight Slasher struck a household not two blocks from my own last night. I inquired with the authorities at the scene about what they're doing to reign in this murder spree, but they didn't even grant me a second glance, waving me off with the usual "Stay off the streets and lock your door!" I know most of them don't trust me, but they're not proving to be trustworthy themselves, either.

Well, I'm not one to sit around, waiting to get dragged off in the middle of the night! I've started training the mastiff pups I bought from Rupert on a lark last month to track a scent, and they've taken to it quite well. They'll make fine hunting and guard dogs soon, so I'll be happy to pass one off to you once they're able to track a scent decently: they're right pleasant company, and it'll help your young ones sleep better. That's at least a month off, though, so just consider the offer for now.

Which brings me to the reason for this letter: the attached package is a blunderbuss, so be sure to unwrap it at home and keep it somewhere hidden, but accessible. I threw some spare powder and buckshot in there too — no, no need to thank me. You helped my father when he was in a rough spot, and Crowleys never forget kindness freely given. Take the gun and keep safe. I fear things are going to get worse before they get better.

Sincerely,
Lorna Crowley

MESSAGE IN A BOTTLE: KEZAN AND THE LOST ISLES

If you're reading this, I'm probably dead. I got shipwrecked with Kezan's other uprooted goblins on some crazy place called the Lost Isles. Hostile jungle critters are making snacks out of my fellow castaways, and I have this sick feeling that I'm next. I'd go on about the strange flora and fauna here, but who cares about some dinky rock out in the middle of nowhere when my life is on the line? Let's focus on what I can do for *you*, and what you can do for *me*.

See, when Mount Kajaro started spewing molten rock all over Kezan, my workshop and all the precious inventions within got blown to smithereens. Luckily I stored the details of these creations in my noggin. Inside this bottle you'll find every schematic to my name... *free* to take. You put these babies to use, and you'll be living like a trade prince in no time. I only ask one tiny thing in return — make sure the world knows who invented these gems of goblin ingenuity. You know: build a few statues in my honor, name your kids after me, that sort of thing. Quite a deal, am I right?

Explorers' League Note: It appears that the author's name was not included on this letter or the hastily scribbled schematics accompanying it.

GOBLIN DEEP SEA DIVER

* GOBLIN COAST HIGHWAY - KEZAN *

GOBLIN TRADE PRINCE

FORGOTTEN DEPTHS: VASHJ'IR

I am a pioneer in the science of underwater exploration — a field that I have titled "Observant Soggination" — and so there is very little under the sea that has escaped my studies. It was during my test run of the ill-fated Fathomscrubber X900 that I first came across the sunken night elf city of Vashj'ir. It's beautiful in a wet, slimy, fallen-down-pillars sort of way. And I would've stayed to scope out the joint [I bet it's just reeking with treasure!] if not for the scaly naga brutes who had issues when my nitro probes crumbled a few of their precious reefs.

Luckily the Fathomscrubber was armed with a failsafe "Break Into Pieces" mechanism that hid my hasty retreat in a cloud of oil, bubbles, and deliberately engineered rust. I wish I could have seen the look on their faces, but I was dodging wreckage as I floated to the surface. My Inflate-o-Briefs kept me safely buoyant until I was picked up by a timely trading vessel.

I plan to return to Vashj'ir someday, and the X901 is going to teach those fish-jerks some respect for science.

—Fiasco Sizzlegrin, Professor of Observant Soggination at IOU [Income Optimization University, Kezan Branch]

GILGOBLIN

MYSTERIES IN THE SANDS: ULDUM

I'm not a prophet; I'm just a gnome who trusts her gut. After the first small tremors started shaking Azeroth, my instincts told me that something even bigger was on its way. Unfortunately, no one else in Gadgetzan shared my healthy paranoia of the coming apocalypse. The old codgers in the city just snickered behind my back when I decided to live in the skies over Tanaris aboard my trusty flying machine, only coming down for food and fuel when absolutely necessary. When the "big one" finally hit as I'd predicted, they weren't laughing anymore.

As the dunes around Gadgetzan rose and fell in waves, all those skeptics were crying like babies while I was safe and sound high in the sky. But I didn't expect what happened next: just over the mountains in southern Tanaris, land appeared out of thin air. Not *just* land, but some kind of civilization with towering obelisks and pyramids covered in strange symbols. A thought ran through my head that this might be the legendary region of Uldum. I wrote the idea off as harebrained until dozens of would-be adventurers started showing up in Gadgetzan, whispering Uldum's name and babbling on about treasure hoards hidden within the area.

With all these fresh faces around, I've been making a fortune selling aerial tours over the mountains near Uldum. More importantly, those disbelievers who treated me like a nut before the quake hit have begun showing me the respect I deserve. If they keep it up, I might just offer them one of my tours... maybe even at a discount!

—Kleesa Gearspring of Gadgetzan

*ULDUM

REALM OF FURY: THE ELEMENTAL PLANE

The titans separated our world from the elemental prison for a reason: those walls were never meant to be breached.

When my former master spoke of his home, of the Skywall, it was always with a mixture of reverence and fury. I asked him about it once, if he would take me there. His laugh knocked me to the ground.

"Oh, no, small one," he said, "that place was built to cage the northern wind, to keep the tempest in chains. A fleshling like you would be torn apart just standing at the threshold."

And now the gates have been flung wide open. Vast kingdoms of fire, sea, and stone—realms equal in savagery to the Skywall—pour their primordial hate into our fragile land. Long did I tremble under the fist of just *one* denizen of the Elemental Plane. Azeroth will shatter beneath them all.

—Highlord Demitrian

* TEMPLE OF THE ELEMENTS *

FIRELANDS

COLOPHON

WORLD OF WARCRAFT TEAM

ART DIRECTOR
Chris Robinson

CONCEPT ARTIST
Mark Gibbons

LEAD CITY/ DUNGEON ARTIST
Wendy Vetter

SUB LEAD CITY/ DUNGEON ARTIST
Jimmy Lo

CITY/DUNGEON ARTISTS
Steve Allen
Patrick Burke
Jeff Chang
Steve Crow
Cole Eastburn
Rutherford Gong
David Harrington
Jonathan Jacobson
Danny Kim
Andrew Matthews
Chad Max
John Staats
Rhett "Stash" Torgoley

LEAD ENVIRONMENT ARTIST
Gary Platner

ENVIRONMENT ARTIST
Justin Kunz
Dion Rogers
Gustav Schmidt

LEAD PROP ARTIST
Eric Browning

PROP ARTISTS
Jamie Chang
Terrie Denman
Dan Moore
Dusty Nolting
Holly Prado
Tiffany Sirignano
Kelvin Tan

LEAD CHARACTER ARTIST/ LEAD TECHNICAL ARTIST
Thomas Blue

CHARACTER ARTISTS
Chris Chang
Danny Beck
Joe Keller
Roman Kenney
Hun Kevin Lee
Kevin Maginnis
Jon McConnell
Danny Saint-Hilaire
Robert Sevilla
Thomas Yip

TECHNICAL ARTISTS
Paul Forest
Joram Hughes
Alexis Meade
Trevor Rothman

LEAD VISUAL ANIMATOR
Steve Aguilar

ANIMATORS
John Butkus
Jeff Gregory
Mauricio Hoffman
Mai Igarashi
John Scharmen
Jason Zirpolo

SPECIAL EFFECTS ARTIST
Slim Ghariani

ADDITIONAL ART
Sam Didier
Brett Dixon
Jon Jelinek
Jason Morris
Anessa Silzer

PRODUCERS
J. Allen Brack
Rob Foote
James Cho

CINEMATICS TEAM

DIRECTOR
Marc Messenger

ART DIRECTORS
Chris Thunig
Fausto De Martini
Jonathan Berube

ARTIST
Bernie Kang
Brian Huang
Mathias Verhasselt
Steve Hui

PRODUCER
Phillip Hillenbrand
Patricia Adams

CREATIVE DEVELOPMENT TEAM

ART DIRECTOR
Glenn Rane

ARTIST
John "JP" Polidora
Phroilan Gardner
Wei Wang

PRODUCER
Kyle Williams

BLIZZARD ENTERTAINMENT

ART DIRECTION
Chris Robinson
Glenn Rane
Jeff Chamberlain

DIRECTOR OF CREATIVE DEVELOPMENT
Jeff Donais

CREATIVE DEVELOPMENT PUBLISHING LEAD
Micky Neilsen

CREATIVE DEVELOPMENT WRITERS
James Waugh
Cameron Dayton
Tommy Newcomer
Matt Burns

CREATIVE DEVELOPMENT HISTORIAN
Evelyn Fredericksen

CREATIVE DEVELOPMENT EDITOR
Cate Gary

CREATIVE DEVELOPMENT PRODUCTION
Kyle Williams
Zachariah Owens
Skye Chandler

MARKETING SERVICES

DIRECTOR
Steve L. Parker

SENIOR BRAND MANAGER
Marc Hutcheson

ART DIRECTOR
Erik Jensen

GRAPHIC DESIGN
Raul Ramirez
Michael Carrillo

PRODUCTION
Caroline Wu
Dave Amason
Beverly Williams

GERMAN LOCALIZATION TEAM
Alexander Böning
Florian Descher
Sebastian Ewald
Stefanie Jahn
Pablo Martín Siota
Katja Raaf
Katharina Reiche
Stefan Schmitt
Andrea Tüger

FRENCH LOCALIZATION TEAM
Claire Bajard
Christelle Bravin
Bruno Cailloux
Stéphane Chapuis
Anne-Sophie Denglos
Thomas Ernoux
Tristan Lhomme
Alexis Roy-Petit
Anne Studer
Anne Vétillard

Danny Beck
41, 49, 116, 122-123, 131, 160

Eric Browning
40, 79, 109, 111, 118, 120,
144-147, 149, 151

Chris Chang
168, 170-171

Jamie Chang
72

Samwise Didier
73, 87

Phroilan Gardner
175

Mark Gibbons
16-22, 24-40, 56, 60, 62-65, 68-72,
74-75, 78-79, 81-82, 86, 90-103,
106, 110, 116, 118, 120-129,
134-138, 141, 148-154, 156-169

Brian Huang
43-47, 49, 58-59, 149

Steve Hui
7, 11-14

Bernie Kang
1, 8

Roman Kenny
62-63, 72, 78-79

Justin Kunz
4-5, 23, 40, 64-65, 68, 70, 77,
86, 88-89, 93, 100, 109 -117,
132-136, 155-157

Hun Kevin Lee
170-171

Peter Lee
50-51, 141, 145-146, 164

Jimmy Lo
5, 47, 42, 54-55, 68, 74, 77, 81,
106-107, 113-115, 123, 138-143,
148, 154

Joe Keller
170-171

Kevin Maginnis
171

Jon McConnell
130

Chris Metzen
47

Gary Platner
97

John Polidora
2-3, 82-83

Glenn Rane
10, 11, 48, 52, 60-61, 66-67,
80, 104-105, 108

Chris Robinson
Cover

Gustav Schmidt
57, 62-63, 84-85, 96, 97, 149

Mathias Verhasselt
11, 14, 56-57, 59, 150

Wendy Vetter
44, 72

Wei Wang
9, 15, 53, 76

Thomas Yip
119